Y

Young
Mothers

Seema Sondhi

wisdom
tree

Published by

Wisdom Tree
4779/23, Ansari Road
Darya Ganj, Delhi-110002
Ph. 23247966/67/68

Printed at

Print Perfect
New Delhi-110 064

*In the loving memory of
my father*

Acknowledgements

Heartfelt gratitude to my dear friend Christine Sharma, for readily agreeing to lend her support at such short notice. Thank you for helping me materialize my dream of spreading knowledge of yoga to those who seek the wisdom of wellness.

Preface

Finally you have your baby in your arms. You deserve a pat on your back for giving birth to a healthy baby. After sufficient rest you will have to face a grueling daily timetable of balancing your household chores, maybe office work, and nursing your baby. In this book you find clear explanations of various exercises, which will help you regain your figure and get rid of the extra weight that you put on during pregnancy. Regular practice of the asanas will definitely tone your body and bring back your vibrant self. Pranayama meditation and relaxation will prove to be beneficial because taking care of the baby will be time-consuming and hectic. Remember to also keep time for yourself.

'Sadhana should be as much a part of your daily life as eating, drinking and breathing.'

—*Swami Sivananda*

Contents

The Miracle of Motherhood

Congratulations on your new baby! Unbelievable, isn't it? The beautiful, perfect, little baby you now hold in your arms was once growing inside you. The creation of a whole new person, a whole new life, is truly a miracle of God. And all the credit goes to you Mom, for keeping yourself and your baby safe and healthy through pregnancy!

For those of you who practised yoga and meditation during your pregnancy, you are most likely to have had a relatively easy labour. And you can now look back and congratulate yourself for your great wisdom in starting with yoga and meditation early on in your pregnancy.

Now that you are back home with your bundle of joy, and your body is your own again, you need to start thinking about getting it back into shape.

Of course, the first few weeks are going to be uncomfortable. You are going to be exhausted, bruised, stretched, dripping and swollen. And you will have cramps! Uterine cramps are normal. It's just your uterus returning to its normal size. You ask yourself... isn't all this

supposed to be over? Take heart, Mom, aches, pains and soreness are a fact of life after delivery. Most wear off within three to five weeks of delivery.

And then, to top it all there are the anxieties. Has your baby been fed enough? How much is too much? Is it normal to sleep so much? Why does the baby cry for no apparent reason? Am I doing this right? And, in addition, suddenly you find yourself trying to keep track of timings, vitamin drops, shots, diapers, rashes, infections, temperatures, and a whole gamut of baby products. Between emergency calls to the paediatrician, countless hours spent referring to baby books, and handling advice from well-meaning friends and relatives, you get stressed out in no time at all. Especially if you're not getting enough of sleep!

Your body is also going through a lot of hormonal changes as it slowly returns to its pre-pregnancy state. And at times, this in itself adds to those 'blues'. Everything seems to slow down, and for some Moms, lethargy sets in and getting anything done takes so much of effort.

You need to get yourself back on track by getting enough of rest and enlisting help from your partner in household chores. Get out of the house. Do things that make you feel good, like a trip out shopping or to the hairdressers, or to see a movie with friends. Don't want to part with your baby? You don't have to. Take walks with your baby in a stroller to keep your spirits up, and in no time you will find your energy returning.

If you exercised regularly throughout your pregnancy and had a

normal delivery, you'll have a much easier time getting back on to the fitness wagon. But forget about picking up where you left off for a while. Instead, start with a modified regime and pick up your pace gradually. There is no gauge to tell you when you are ready to go full force, and it will vary from person to person. You will need to check yourself to see if you can push your self longer and farther.

Unfit Moms, who did not have regular exercise throughout their pregnancy, those that had a caesarian birth or an episiotomy will take longer to recuperate. You will need to start slowly but regularly and work your way up.

Ease into a light exercise regime and it will soon work wonders for you, both physically and emotionally. Our post-pregnancy yoga exercises will help you to gently tone your muscles and internal organs, give you back your youthful figure, and restore your calm confidence.

'Life is a celebration, enjoy each moment by living in the present.'
—The Yoga Studio

The Profound Benefits of Yoga

People often question why yoga and why not any other physical exercise? The answer to this was found thousands of years ago by ancient *yogis*, who had a deep understanding of man's essential nature and what he needed to live in harmony with himself and his environment. Yoga is a complete science of life—it unites the mind, body and the spirit.

Anybody can practise yoga; you do not need special equipment or clothes. All you need is a small quiet space and a yearning for a healthier, quieter life. Regular practice of yoga will give you a fit and beautiful body, increase your energy and vitality, reduce stress and increase your powers of concentration and discipline.

Unlike other physical exercises, yoga is gentle. It does not involve the use of rough, intense movements that could cause injury, stiffness and fatigue. Instead, the poses or *asanas* stretch and tone the muscles, joints, the spine and the entire skeletal system. And, with regular practice, you will experience increased clarity, improved mental power and deeper concentration. This is not so with other forms of physical exercise.

In yoga, the exercises also massage and stimulate your internal organs, glands and nerves, keeping every cell and tissue rejuvenated and making your body fit, both externally and internally.

Correct breathing forms an integral part of the practice of yoga. *Pranayama* or the science of breath control is about using breathing techniques to control your state of mind. It releases stress from your body, steadies your emotions and brings clarity to your mind. Breathing exercises also improve circulation and revitalise the nervous system.

Relaxation is an important part of a yoga session and this is done through autosuggestion, resulting in your body and mind getting recharged. The practice of positive thinking and meditation gives increased clarity, mental power and concentration. Meditation will help you to cope with your mood swings caused by hormonal imbalances, soothe your nerves and readily accept the changes that your body is undergoing.

Even if you have never tried yoga before, you will feel the difference after just a few sessions. In this book, every exercise has been thoughtfully put together to help you gradually and systematically lose the extra weight, get your body toned and relaxed and make you feel radiant and energetic once again. So let's move ahead and begin this wonderful journey of getting the mind and body back into top condition.

'Anyone who practises can obtain success in yoga, but not one who is lazy. Constant practice alone is the secret of success.'
—*Hatha Yoga Pradipika*

Shaping Up Post-pregnancy

After the nine-month marathon of pregnancy and labour, you must be tired and exhausted but yearning to get rid of the unwanted flab and return to your normal, beautiful self as quickly as possible. Coping with being a new Mom will be very time-consuming, but do set aside a little time each day when you can be just 'you' and focus on doing things that make you happy and keep you motivated.

Our post-pregnancy yoga exercises are designed to help you remain fit, internally and externally. You will lose those extra kilos by stretching and toning your muscles and all your internal organs as well. The exercises will also help you to get your reproductive organs back into shape.

Even if you have not done yoga during pregnancy, this is really the perfect time to begin. Yoga will give you the flexibility of body and mind to withstand all the experiences of the months to come.

Post-pregnancy yoga classes are aimed at relieving the body of all the discomforts of post-pregnancy like backaches, uterine cramps, stiffness and digestion and at the same time increasing your body's

suppleness and resilience. Post-pregnancy *asanas* help in releasing a set of energy boosters into your system, which you need as you cope with your multiple responsibilities.

The fastest way to lose weight is by combining yoga with a healthy diet. Remember, there is no single dieting formula for everyone. The important principle is to strike a perfect balance between your calorie intake and the calories you burn.

How soon can you get started? If you have had a normal delivery, you can start your yoga exercises after four to five weeks. If you have had a caesarean section, it's best to start after eight weeks in consultation with your doctor.

Create time for yoga and you will find your body and mind responding to its wonderful gifts. You will soon achieve the strong, healthy and toned body that you want. Your mind will be focused, energised and serene. As you achieve your goals, you will find balance in everything you do, and you will create a warm, happy and secure environment for your newborn and the rest of your family.

'The young, the old, the sick and the infirm obtain perfection in yoga by constant practice. There is no doubt in this.'
—*Hatha Yoga Pradipika*

Weight Loss through Yoga

The renowned sage Patanjali, in the *Yoga Sutras,* compiled a series of steps or disciplines that purify the body and mind, ultimately leading to enlightenment. These eight steps are *yama, niyama, asana, pranayama, pratyahara, dharana, dhyana* and *samadhi.*

By incorporating these basic principles into your daily life while you work towards achieving your goals, you can become a better human being and attain the quest of your soul.

Yamas or restraints are moral disciplines aimed at destroying the lower nature: *ahimsa, satya, asteya, aparigraha* and *brahmacharya.*

Ahimsa or non-violence has an all-encompassing connotation. It means that you must take care not to harm your body, or the body of any other living being. As you practise your yoga exercises, you need to treat your body gently and with respect, and move into your postures gradually.

Satya means truthfulness in word, thought and deed. Say what you mean, and mean what you say. Always be truthful to yourself regarding your diet and *asana* practice. Remember: cheat on yourself and the only loser is you.

9

Asteya or non-stealing signifies that whatever you do, you must do openly. The same goes for your diet and practice.

Aparigraha means non-possessive. Share your knowledge, your skills, your good thoughts and deeds. Be generous in your attitude to others. Help and support those in need.

Brahmacharya literally translated means 'continence' but really advises moderation in all things. Never overindulge yourself in anything you do, be it exercise, diet, lifestyle or habits. Always be in full command of your thoughts and actions.

Niyamas or 'observances' foster the purification of self through discipline and is also divided into five disciplines. Purity or *saucha*, contentment or *santosha*, austerity or *tapas*, study of scriptures or *svadhyaya* and lastly, surrender to the Divine or *isvarapranidhana*.

Saucha represents purity. Treat your body like a temple. Keep it clean and disease free. Eat pure and healthy food (sorry, no junk food!). Release all negative thoughts from your mind and replace them with good thoughts and feelings.

Santosha is contentment. Never ever compare yourself with others. You are special. You have been created unique, one of a kind. Be satisfied with yourself, your capabilities and your strengths. Have patience with your limitations, especially in your practice of yoga. In time, you will achieve all that you set out to do.

Tapas means austerity. You need to lead a simple, ascetic and disciplined life; no excesses, no ostentation, no indulgences. Be ready

for hard work, as it is this hard work that will reap benefits later on.

Swadhyaya or study of the scriptures has its obvious meaning. If you are a religious person, then follow the teachings of your disciples and saints, and enrich your soul. If you do not believe in the Divine, read inspirational stories of truth and courage that motivate and propel you towards a better life. Surround yourself with good people and you will always be positive and fulfilled.

Isvara Pranidana is literally to surrender to a higher purpose. Put your mind, soul and faith in the work that you are doing without looking for the results. Remember, for any action, there is sure to be a reaction. Keep focused on your goal and you will ultimately achieve it.

In the practice of *hatha yoga*, the *yama* and the *niyama* are critical to actualise not only your goal of weight loss, but also your emotional and physical well-being. It may mean that you will have to change your lifestyle, but the rewards more than compensate. When you practise *yama* and *niyama*, you control your emotions and passion and keep them in balance to benefit your body and mind.

Asana and *pranayama* help your body and breath to be healthy. Your mind will be trained to be in command of yourself and to be stable.

Pratyahara controls your senses and helps you to draw inwards, still the mind and discard all that is not good for the body and mind.

The final stages will take you on the journey of the 'self' through the art of meditation. You will move inwards to release all negative thoughts and fill your mind with positive beliefs about yourself.

Now let us take you into this yogic journey to discover the perfect harmony in your body and mind.

'Do not feed bad habits with bad actions. Starve them out by self-control. Feed good habits with good actions.'
—Sri Parmahansa Yogananda

5

Getting Started

Those of you who have practised yoga during pregnancy know exactly what is needed before you embark on your sessions. It may take a few days before you actually get back into a proper routine, but don't let that get you down. Babies tend to be a little unpredictable at first, but in the first few weeks you will find that they establish their own little routines, leaving you free to tailor your schedules accordingly.

If you have never practised yoga before, you will need to follow some simple but important guidelines to get the most out of your yoga sessions.

1. Choose a well-ventilated room, or if possible, the outdoors for practise. Try to set aside a specific time each day, preferably while your baby sleeps. Ideal times are before eating and early in the morning.

2. Try and get into the habit of doing the *asanas* at the same time everyday. But if you miss a session, don't let it bother you; you can always continue the next day.

3. You need a soft mat on which to perform your ground postures. These are easily available at any exercise/sports store. Turn off the phone and give instructions not to disturb you for an hour, unless it is important.

4. Dress in loose, comfortable clothing, preferably cotton as your body needs to breathe during your sessions. Leave your feet bare and remove your watch or any jewellery that you may be wearing.

5. Put on some light music, as it will be soothing and will help you to take your mind off the discomfort you may experience during stretching.

6. When doing the exercises, work at your own pace. Never push or strain your body. Always come out of an *asana* if you feel any discomfort. Do your postures calmly and gently, avoiding rough jerky actions when you bend, stretch or twist.

7. Hold each *asana* for 20 or 30 seconds, unless otherwise mentioned. After each *asana*, relax with *shavasana* and breathe.

8. Avoid *asanas* during your menstrual periods.

9. Try and rope in friends so that you have company and are motivated to continue your practice. It is fun to practise in a group.

10. Be patient. It takes time for your body to respond. Don't give up if you don't see results right away. Do remember that an hour of yoga can help you to burn 600 calories, depending on your body type.

Sequence of the *Asanas*

A*sanas* are postures to be held rather than exercises, and are performed slowly and meditatively, combined with deep abdominal breathing. These gentle movements not only reawaken your awareness and control your body but also have a profound effect spiritually. At the end of the session, you will feel relaxed and full of energy.

As our focus is going to be on the toning up of your abdominal muscles and those specific internal organs that were used during your pregnancy, we start with the feet and gradually work our way upwards. Always remember, in yoga the sequence of exercises is very important and each *asana* is designed to complement the other. The easier *asanas* come first, the more difficult ones later. More advanced variations are natural progressions of their basic forms, and you will be able to get into the more advanced levels as you progress. Remember, however adept you are, you should proceed systematically so that you gradually warm up your body for the more difficult poses.

Ready to go? Let's start then.

Uttan Padasana or Foot Stretch Pose

This *asana* will have a wholesome effect on your entire body. It tones the hips, thighs, legs and abdominal muscles. At the same time it will improve your digestion and circulation. It is also very helpful for your entire nervous system and in reducing stress and fatigue.

- Lie down on your mat, flat on your back with legs together and toes flexed out.
- Place your hands by your sides with palms facing the floor. Inhale deeply.
- Exhaling slowly, raise your legs, arms, shoulders, head and trunk off the floor (your shoulders and feet should be no more than 15 cm off the floor).
- Balance your body on your hips, keeping your spine straight. (Your arms should be at the same level and in line with your toes. Your hands should be open with palms parallel to each other.)
- Hold the pose for a few seconds. Exhale and release the pose.

Repeat for two more rounds.

Take care if you have a weak lower back. If you experience even the slightest pain, discontinue the posture and instead try and perform Variation.

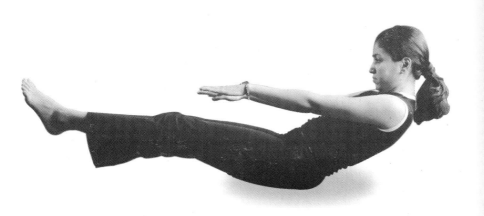

Variation

- Lie flat on your back with legs together and toes flexed out.
- Place your hands by your sides with palms facing the floor.
- While exhaling, raise your upper body, both hands and your right leg. Hold this position for a few seconds.
- Release the posture and repeat the same sequence using your left leg.

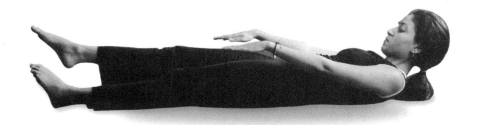

19

SUPTA PADASANA OR SUPINE LEG RAISER

This *asana* tones and strengthens your lower back and abdominal muscles and at the same time massages the internal organs, specifically the reproductive organs.

- Lie flat on your back with legs together.
- Place your hands by your sides with palms facing the floor.
- Keep your head straight with chin tucked in.
- Inhale. Raise your right leg straight up, till it is 90 degrees to your body. If you cannot do this, then raise your leg to the point where you feel comfortable, keeping your knee straight. Hold for a few seconds.
- Exhale and gently lower your right leg down.
- Repeat for 8 to 10 counts. Relax and continue the same with your left leg.

Take care to breathe normally while holding the posture.

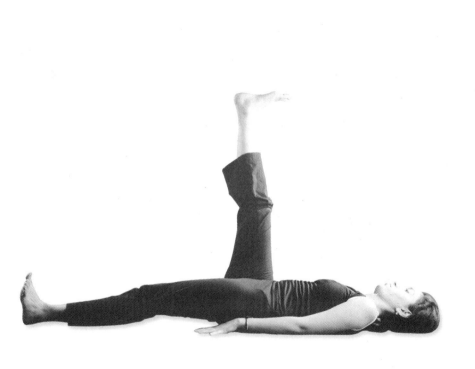

Supta Padasana or Double Leg Raiser

- Lie flat on the floor with legs together and arms by your sides with palms facing the floor. Keep your head straight, with chin tucked in.
- If you have a weak back, then slide your hands under your hips with palms facing the floor for added support.
- Inhale. Raise both legs up to 90 degrees or as far as you feel comfortable, keeping the knees straight.
- Exhale. Bring both the legs down gently.

Continue for 10 to 15 rounds and then relax.

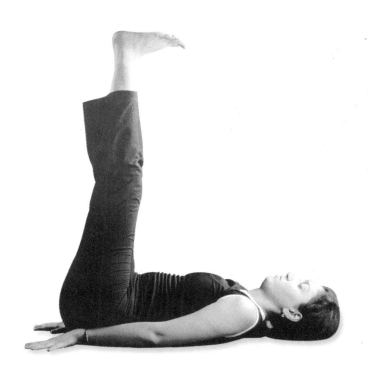

ANANTA ASANA OR SIDE LEG RAISER

This *asana* is excellent for strengthening the pelvic region and stretching the hamstring muscles. It is also really good for toning the hips, calf muscles and thighs.

- Lie flat on the floor. Turn to your left side, resting your body in contact with the floor.

- Raise your head and support your body by bending your arms at the elbow, placing the palms on the floor. Stay in this position and breathe normally.

- Inhale. Keeping your knees locked tight, raise your right leg as high as you feel comfortable.

- Exhale. Bring your leg down. Repeat 8 to 10 times.

- On the last count, bend your right leg in, towards the chest, and hold your big toe with your right hand.

- Exhale. Stretch your right leg and arm upward together, keeping your knees as straight as you can. Hold this position for 20 to 30 seconds (or more), breathing normally.

- Exhale. Bring your right arm and leg down to release the posture. Now repeat the same sequence with your left leg.

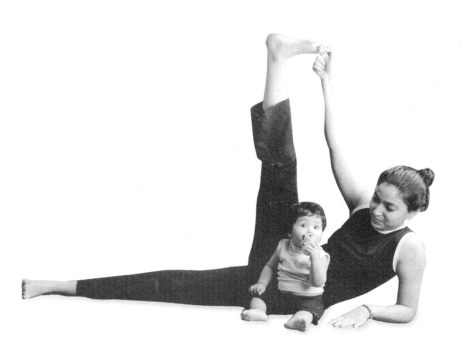

SARVANGASANA OR SHOULDER STAND

This *asana* is particularly good for women, and more so after pregnancy as it helps to get your internal body back in shape. It is beneficial for urinary disorders, uterus displacement, menstrual irregularities, and has a very positive effect in balancing your hormones.

Shoulder Stand

- Lie flat on the floor with legs together, arms by your sides with palms facing the floor.
- Inhale, raise both legs up by pushing down on your hands (Pic. A).
- Lift your hips and legs off the floor, over and beyond your head at an angle of about 45°.
- Exhale, bend your arms and support your body, holding as near the shoulders as possible, with the thumbs around the front of the body, fingers around the back. Push the legs and lift the legs up.
- Slowly straighten the spine and bring the leg up to a vertical position, pressing the chin firmly into the base of your throat. Breathe deeply in the pose, gradually trying to work the elbows close together and your hands further down your back, towards the shoulder.
- Breathe slowly and deeply, holding the position for 20 to 30 seconds.

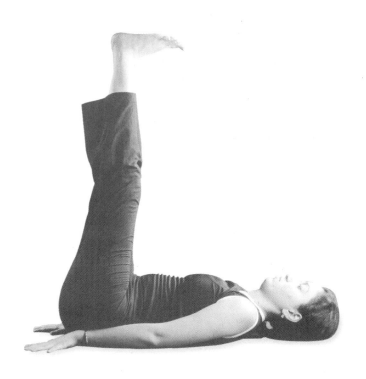

- To release the posture, lower your legs to an angle of 45°
 over the head, place the palms down behind you, and slowly
 roll down, breathing normally until your whole spine is resting
 on the floor.

Take care not to jerk into the posture and bring the chest forward to
touch the chin and not the other way round, i.e. do not push your
chin outwards to touch the chest.

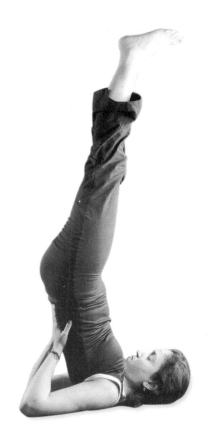

HALASANA OR PLOUGH POSE

This *asana* tones your entire lower body. It benefits the abdominal organs and relieves pain in the back, as your spine will receive a good supply of blood. It also releases the stiffness in the shoulders, elbows and back.

This *asana* is a straight continuation from *sarvangasana.*

- Gently bring both legs down but towards the back of your head, keeping your back continuously supported with your palms.

- Touch your toes on the ground behind your head, transferring your weight to your toes.

- Straighten your legs by keeping your knees straight. Make sure that your toes are pointing inward, towards your head, while your heels are pointing up.

- Contract your hip muscles and pull in the abdominal muscles.

- If your toes are firmly supporting your weight, slowly release your arms (which were supporting your back) and place them flat on the floor, parallel to each other or interlock your fingers.

- To release the posture, return to the *sarvangasana* and then slowly lower the body down.

Take care not to push the body too far. Move gently and take all the time you need to get into this posture.

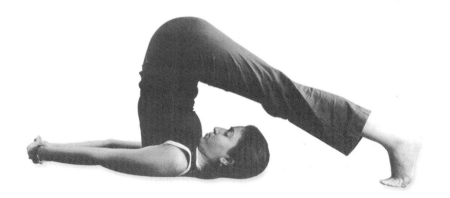

Pawan Muktasana or Wind-releasing Pose

This *asana* strengthens your lower back muscles and massages your abdominal muscles, helping in digestion and elimination of wind. It helps to relieve constipation. It also tones the reproductive organs and is extremely beneficial for menstrual problems.

- Lie flat on the ground with your arms at your sides and palms facing the floor and both legs together.
- Raise both legs, bend at the knee and bring your thighs upto your chest.
- Wrap your arms around your legs and press them towards your chest. Relax in this position for a few seconds.
- Lift your head and shoulders off the ground and try to touch your forehead in the space between the knees. Breathing normally, hold this position for 20 to 30 seconds.
- To release the posture, lower your head, shoulders and legs down to starting position.

Take care to push your lower back against the floor.

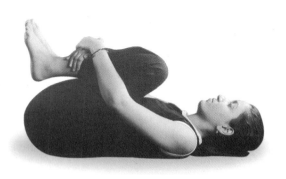

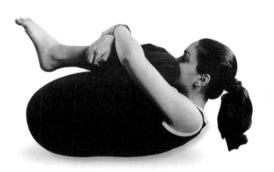

33

CHAKRASANA OR WHEEL POSE

The *chakrasana* is a great all-round toner. It stretches your spine and reduces any stiffness. This *asana* has a wonderful effect on the nervous, digestive, respiratory and cardiovascular systems. It relieves the body of many gynaecological disorders. It has a good effect on hips, knees, thighs, calf muscles and your ankles.

- Lie flat on your back with legs together.
- Raise your arms, bend them backwards and place your palms on the floor on either side of your head. Your fingers should be pointing towards your feet.
- Keeping your feet on the floor, bend your knees and bring your feet towards your body till your ankles touch your hips. Keep your feet and palms comfortably wide apart.
- Lift your hips and the spine upward, pressing down on your hands and resting the crown of your head on the floor. Rest briefly, breathing normally.
- Raise your body slowly by arching the spine and pressing on your palms and feet.
- Hold the position as long as you feel comfortable.
- Release the posture by gently lowering your body to the floor.

Take extreme care not to push yourself beyond your body's capacity.

Beginners can start by doing this asana *up to the fourth step, and proceed further when they gain enough strength and confidence.*

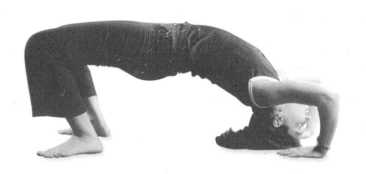

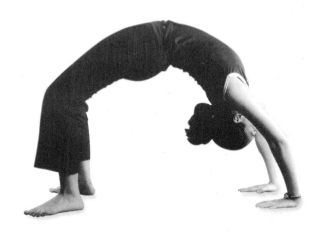

Setu Bandh Asana or Bridge Pose

This *asana* is excellent for the muscles of the hips, thighs and calves. It increases the flexibility of your spine and massages the liver and spleen. It tones the reproductive organs and is very beneficial after childbirth.

- Lie flat on your back with the legs apart.
- Place your arms by your sides with palms facing the floor and head straight.
- Bend your knees, bring them up towards your hips with your feet firmly on the ground.
- Bend the hands from the elbows and using your palms to support your lower back, lift your hips off the flor, giving a good arch to the spine. Hold this position, breathing normally.
- Release the posture by bringing your hips and arms back to starting position.

When arching your body, take care not to overstretch your spine. Keep your weight on your feet and elbows and your hips contracted for full benefit.

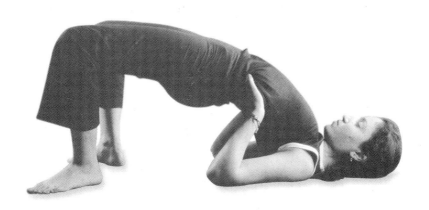

BADDHAKON ASANA OR BUTTERFLY POSE

This *asana* increases the flexibility of the hips, inner thighs, pelvis, lower back, knees and the ankles. It tones the reproductive organs and is also very helpful in correcting menstrual problems.

- Sit on the floor with the spine held straight.
- Bend your knees, join the soles of your feet together by bringing your heels inward towards the perineum.
- Inhale. Lift your lower back and elongate by extending your entire spine.
- Exhale. Place your elbows on your inner thighs and bend forward from the hips, extending your torso towards the floor. Touch your forehead on the ground.
- Breathe deeply and slowly, holding the posture for 20 to 30 seconds.
- To release the posture, gently lift the head up and relax.

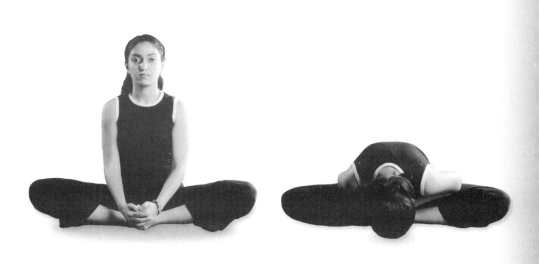

JANUSHIRASANA OR HEAD TO KNEE POSE

This *asana* tones the entire lower body and the abdominal muscles. It stretches the hamstring muscles and increases hip flexibility.

- Sit on the floor with legs together and stretched out in front of you. Keep your spine straight.
- Bend your left knee and place the sole of your left foot against the inner side of the right thigh. Touch your left knee on the floor. Close your eyes in this position. Relax your body.
- Inhale deeply, raising both your hands straight up.
- Exhale. Bend forward over your right leg, sliding your hand along your leg till you reach your foot. Hold on to your foot, or if possible, your big toe.
- Lower your head and touch your forehead to your shin. Hold this position for 20 to 30 seconds.
- Inhale. Lift your torso up slowly and relax.

Repeat two to three times on the right side; then repeat the same sequence on the left.

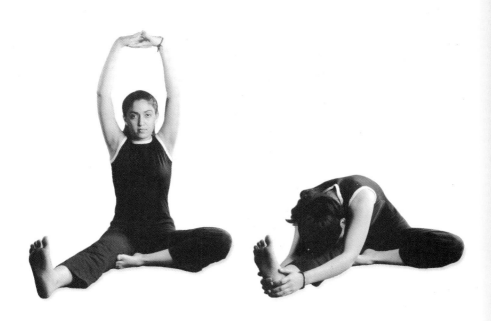

CHAKKI CHALANASANA OR CHURNING THE MILL

This *asana* is excellent for postnatal recovery. It tones the entire nerves and organs of the abdomen. It also helps in regulating the menstrual cycle.

- Sit in the floor with your legs together and stretched out in front of you.

- Separate your legs and slowly widen the distance between them as far as you can go, making sure that the back portions of your legs rest firmly on the floor.

- Interlock the fingers of both your hands and raise them above your head, keeping your back erect.

- Turn your body towards the right. Exhale and extend your body forward towards your right leg, touching your right toe, if possible. Stay in this position for a few seconds, breathing normally.

- Inhale and slowly come up.

- Keeping the spine erect, raise your hands. Exhale and bend forward towards the centre of both your legs, touching the palms of both hands on the floor.

- Stretch your lower back even more forward by contracting the abdominal and hip muscles and try to touch your forehead on the ground, if possible. Stay in this position for a few seconds,

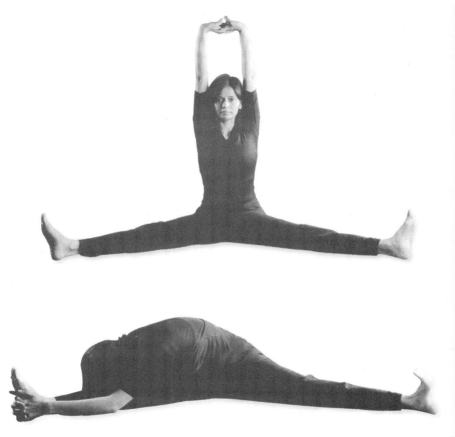

43

breathing normally.

- Inhale and slowly come up.
- Now turn your body to the left. Exhale and extend your body forward towards your left leg, touching your left toe, if possible. Stay in this position for a few seconds, breathing normally.
- Inhale and slowly come up.

Repeat 3 to 5 times.

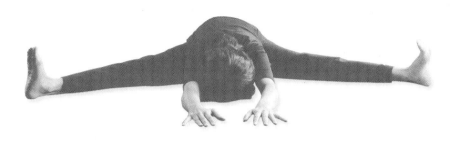

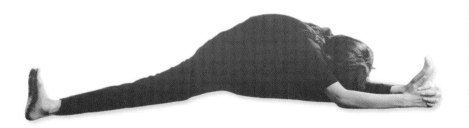

45

Paschimottan Asana or *Forward Bend*

This *asana* rejuvenates the whole spine, tones the abdominal organs and is very effective in toning the hips, thighs and abdomen.

- Sit on the floor with legs together and stretched out in front of you. Place your palms on the floor by the side of your hips and keep your spine erect.
- Inhale. Raise both your hands straight up, stretching your spine upwards.
- Exhale and bend forward to reach your toes. Hold your toes or hold the ankles with both hands, if possible, and place your forehead on your knees. Hold the posture for a few seconds breathing normally.
- Inhale. Slowly lift yourself back into the starting position.

Repeat 2 to 3 times.

Take care to move slowly and carefully in this asana.

Women with backache should not practise this asana.

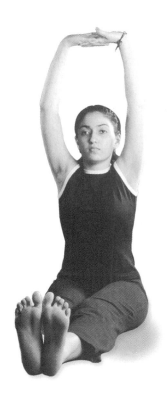
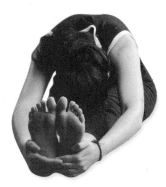

VAJRASANA OR ADAMANTINE POSE

This is the only *asana* that can be done after eating a meal, as it aids in digestion and is highly recommended. The body becomes strong and firm and the mind relaxed.

- Kneel down on the floor.
- Bring the big toes together and separate the heels.
- Rest the hips on to the surface of the feet with heels touching the sides of the hips.
- Close your eyes, relax the body and breathe normally.
- Stay in this posture for as long as comfortable.

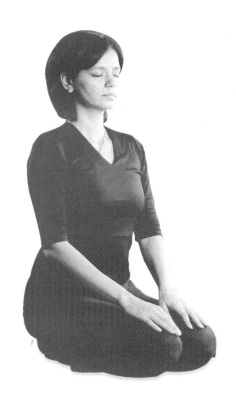

ARDH MATYSENDER ASANA OR SPINAL TWIST

The spinal twist rejuvenates the nerves of your spine and makes your back flexible. It massages the abdominal organs and rids the body of the toxic byproducts of digestion. It regulates the secretion of adrenaline and bile and is extremely helpful in diabetes, menstrual disorders, urinary tract infection, spondylitis, and colitis.

- Sit in *vajrasana*. Lower your hips to the floor on your left side.
- Left the right leg over your left, placing the right foot close to the left hip.
- Stretch your right arm up and bring it behind your back, palm on the floor to support and keep the spine straight.
- Stretch your left arm up and bring it over the right side of your right knee.
- Reach out and hold your right ankle.
- Look over your right shoulder. Breathe deeply in this position for 20 to 30 seconds.
- Release the posture and repeat the same sequence on the left side of your body.

Women with backache should take care when twisting their torso.

Those who have stiff bodies can make adjustments to the position and try variation.

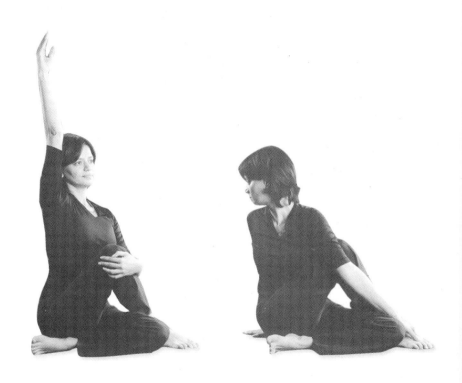

Variation

- Place your left leg straight and your right leg crossed over the left leg, near the left knee or the hip.
- Place your right hand behind your back, palm on the floor and your left hand wrapped around the right knee, hugging your knee to the chest and look over the right shoulder.

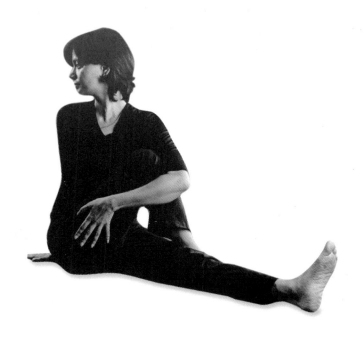

Gomukhasana or Cow Pose

This *asana* opens the chest area, helps in toning the breast muscles and facilitates lactation. It induces relaxation and releases tension from the body. It reduces leg cramps by making the leg muscles supple.

- Sit in *vajrasana*. Lower your hips to the floor on your left side, with the left leg bent and ankle touching the right hip.
- Cross your right knee over the left knee so that the right heel touches the left hip.
- Bend your right arm from the elbow. Take it behind your back, towards your right shoulder.
- Bend your left arm at the elbow and take it behind your back to hold the right hand (if possible).
- Keep your spine and head straight. Close your eyes and stay in this position for 20 to 30 seconds, breathing slowly and deeply.
- Release the *asana* and repeat the same on your left side.

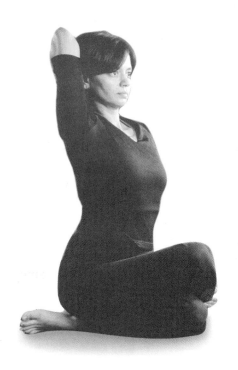

SHALABHASANA OR LOCUST POSE

This *asana* is very good for stretching the spine, making it elastic and relieving pain in the sacral and the lumbar regions. It is most beneficial for people suffering from a slipped disc. This *asana* also aids digestion and helps to tone the entire body.

- Lie flat on your stomach with your face down and the arms under the thighs, palms facing upwards.
- Slowly raise your head, chest and the legs off the floor simultaneously and as high as possible.
- Contract your hip muscles and stretch your thigh muscles, keeping both legs fully extended.
- Stay in this position for as long as possible with normal breathing. Release the posture and relax your body.

Repeat the posture 2 to 3 times.

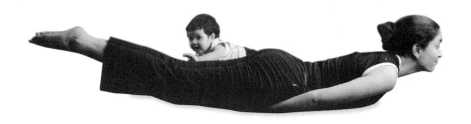

Bhujangasana or *Cobra Pose*

This exercise relieves indigestion and constipation and helps in elimination of waste products. It removes backache and makes the spine supple and healthy. It also tones the ovaries and the uterus, and helps to get rid of gynaecological disorders. It is very beneficial for all abdominal organs, especially the liver and kidneys.

- Lie on your stomach with forehead touching the floor, and your legs and heels together.
- Place your palms flat on the floor, directly below the sides of your shoulders, with fingertips in line with the top of your shoulders and elbows inwards.
- Inhale, raise your head and trunk up by pressing on the hands.
- Stay in this position for 20 to 30 seconds, breathing normally.
- Exhale gently lower your body to release the posture. Relax.

Repeat 2 to 3 times.

Take care not to overstretch your back. Let your body take its own time to get into the posture.

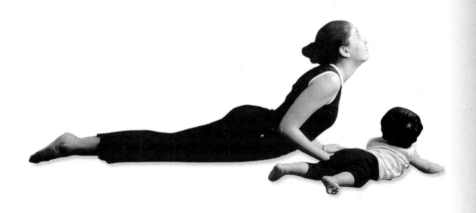

Dhanurasana or *The Bow Pose*

The bow pose raises both halves of the body simultaneously. It stretches your spine backwards, massaging the entire back and the internal organs. It increases vitality and provides relief from intestinal disorders.

- Lie flat on your stomach with your face down and the forehead touching the floor. Keep your arms and hands close to your body.
- Bend your knees, bringing your heels close to your hips. Allow your knees to separate slightly.
- Hold your right ankle with your right hand and left ankle with your left hand.
- Inhale. Lift your head and chest off the floor, simultaneously raising your knees and thighs off the floor.
- Arch your body backwards and look up.
- Stay in this position for 20 to 30 seconds, breathing normally.
- Slowly bring your head, chest and legs down to release the posture.

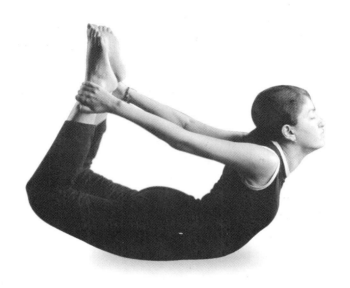

61

Asvathasana or *Holy Tree Pose*

This *asana* ensures proper intake of oxygen into your body and releases carbon dioxide and other gaseous impurities, thus making your body healthy and strong. It also improves your overall circulation.

- Stand erect with feet together and big toes touching each other.
- Inhale. Raise your right foot backwards as far as possible. At the same time, stretch your right arm sideways, parallel to the floor and extend your left arm upwards, expanding your chest.
- Stay in this position for 20 to 30 seconds, then release the posture.

Repeat the same sequence by alternating the legs at least thrice.

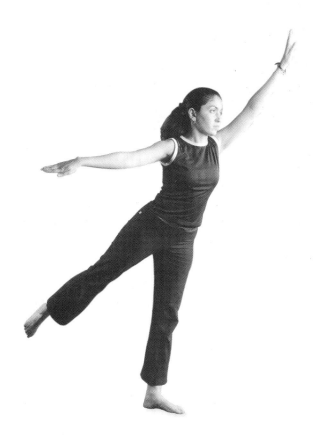

UTKATASANA OR CHAIR POSE

This *asana* tones and strengthens the muscles of your thighs, hips and legs. It also massages your abdominal organs and tones your spine.

- Stand erect with feet together. Inhale. Stretch your arms up over your head and join your palms.
- Exhale. Lower your body, bending your knees till your thighs are parallel to the floor.
- Stay in this position for 20 to 30 seconds, breathing normally.
- Slowly raise your body up again and release the position.

Take care not to stoop forward and keep your chest out as far as possible.

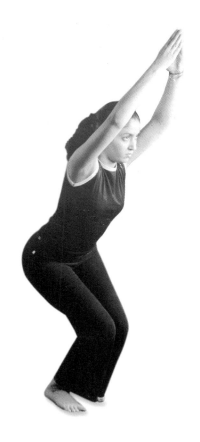

TRIKONASANA OR TRIANGLE POSE

The triangle pose is excellent for toning the muscles of the entire lower body. It results in fat loss around the hips and thighs. It removes back pain and makes the spine supple, as it is a lateral stretch.

- Stand with your feet 3 to 4 feet (75 to 100 cm) apart. Turn the right foot outwards, 90 degrees to your body and left foot slightly inwards, towards the right. Extend your arms at shoulder level.
- Exhale, bend the body sideways to the right and try to hold on to the lowest part that you can reach. Look out at your left hand.
- Stay in this position for 20 to 30 seconds. Breathing normally, slow bring your body up and release the posture.
- Repeat, the same sequence with the left leg.

Take care to move into the posture slowly and gently.

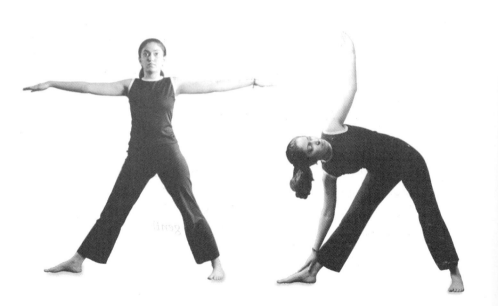

UTTHITA PARSVAKONASANA OR LATERAL ANGLE POSE

This *asana* tones your abdominal organs, ankles, knees and thighs. It also reduces the fat around your waist and hips and relieves back pain.

- Stand straight, with feet 4 to 4.5 feet (100 to 110 cm) apart.
- Raise your arms sideways, in line with your shoulder and palms facing down.
- Turn your left foot outward, 90 degrees to your body and point your right foot slightly inwards.
- Exhale. Lowering yourself gently, bend your left leg at the knee until the thigh and calf form a right angle and your thigh is parallel to the floor.
- Place your left palm on the floor by your left foot. Your left armpit should be touching the outer side of your left knee.
- Stretch your right arm over your right ear, keeping your head up all the while.
- Stay in this position for 20 to 30 seconds. Slowly come up and release the posture.

Repeat the same on your left side.

Move into this posture very slowly and stretch every part of your body for full effect.

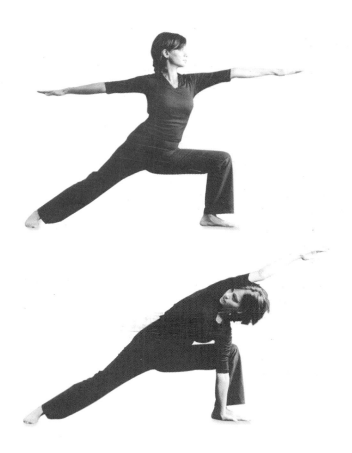

PADA HASTASANA OR STANDING FORWARD BENDS

This *asana* invigorates the entire spine and the nervous system. It increases the blood supply to your brain and is an excellent posture to reduce fat around your lower body.

- Stand straight with feet together and the toes touching.
- Inhale. Raise both arms straight above your head.
- Exhale. Stretch your body forward, bending downward from your hips.
- Touch your forehead to your knees and place the palms close to your feet or hold both ankles from behind.
- Stay in this position for as long as comfortable, breathing normally.
- Inhale. Slowly come up and release the position.

Repeat the sequence thrice.

Make sure that the weight of your body is centred on the balls of your feet. Stretch your hips upward during this posture and keep your knees straight.

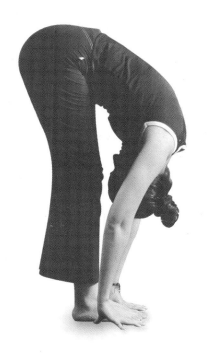

Mandukasana or *Frog Pose*

This *asana* relieves all the stress from your spine, inner thighs, knees and shoulders. It should be practised for relaxation of your body as it helps to distribute energy evenly throughout your body.

- Lie on the floor, flat on your back.
- Bend your knees and drop them outwards, pressing the soles of the feet together and lowering your thighs to the floor.
- Move your hands 3 or 4 inches (7 to 10 cms) away from your body with the palms facing upwards.
- Close your eyes, and relax your lower back by pressing it to the floor gently.

Stay in this position for as long as possible, breathing normally.

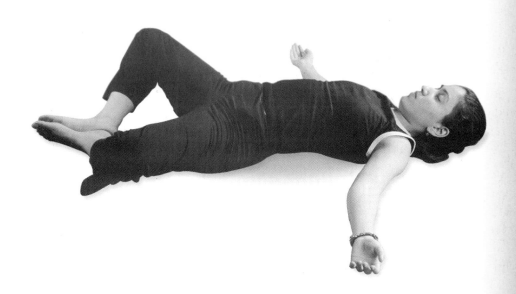

73

SHAVASANA OR CORPSE POSE

This *asana* releases all the fatigue and stress from your body and mind. It relaxes the entire nervous system and recharges the body.

- Lie flat on your back, on the floor. Keep your hands stretched out alongside your body with palms facing downwards.
- Position your legs straight out, about 2 feet (60 cm) apart, toes relaxed and feet lying out naturally.
- Close your eyes and let your entire body relax completely.
- Focus your mind on your breathing and shut out external noises.
- Slowly roll your head from side to side, allowing your breathing to stay normal. Stay in this position for as long as you want.

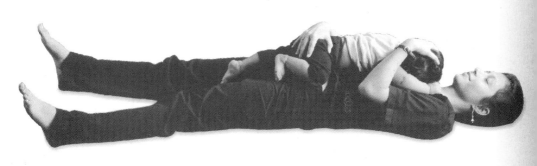

Surya Namaskar or Sun Salutation

'I salute the primeval Lord Siva, who taught Parvati the hatha *yoga* vidhya, *which is as a stairway for those who wish to attain the most excellent* Raja Yoga.'

Surya namaskar *is the best yogic exercise as both the benefits of* asana *and* pranayama *can be attained in this series of 12 postures.* The sun salutation makes your entire body flexible and prepares you for the other *asanas*. It tones, stretches and massages all the joints, muscles and the internal organs. It also helps to regulate your breathing and focuses your mind. It recharges your solar plexus and stimulates the cardio-vascular system.

Sun salutation should be ideally done early in the morning, facing the sun and each moment of the body is synchronised with your breath. However, if that is not possible, then it may be practised at any time on an empty stomach.

Since this is one of the busiest periods of your life, you may do *Surya Namaskar* as an *asana* in itself with each *asana* of 6 to 12 sequences depending on your capacity. And if you find it difficult to synchronise your breathing, then it is quite alright to breathe normally in the beginning.

Let's start:
Begin by standing straight up, with legs together and your arms by the side of your body. Close your eyes and become aware of your entire body. Begin to relax your body mentally.

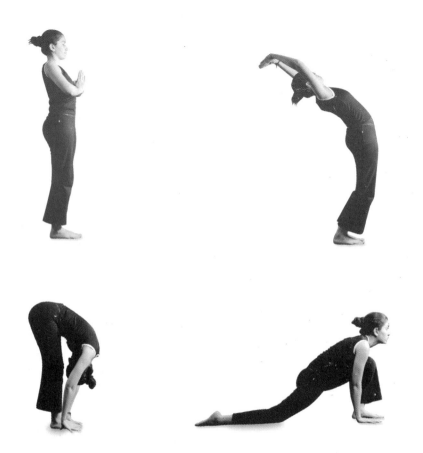

Position 1

Exhale. Join your palms together in a *namaskar* position in front of your chest and mentally pay your respects to the Sun-god: *Om Surya Namah*!

Position 2

Inhale. Stretch your arms straight up above your head, arching your body backwards. Knees and elbows should be straight with your arms close to either sides of your ears.

Position 3

Exhale. Slowly bend forward, bringing your hands to the floor, next to your feet. Try to touch your forehead to your knees, keeping your knees straight. Don't strain.

Position 4

Inhale. Without moving your hands, stretch your right leg backwards as far as possible. Placing your right knee on the floor, stretch your head upwards.

Position 5

Exhale. Move your left foot in position by bringing it next to your right foot. At the same time, lift your hips and lower your head between your arms so that your back and legs form a perfect

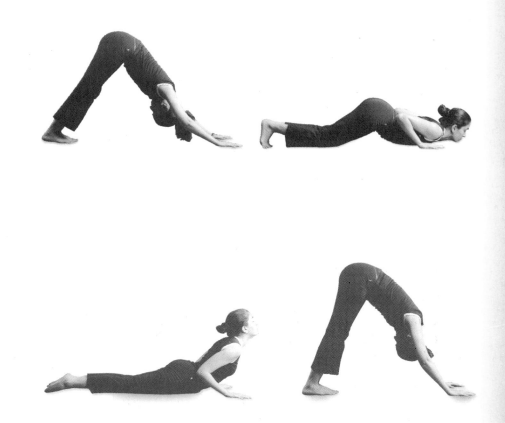

triangle. Push your heels towards the floor and your palms should be flat on the floor.

Position 6

Retain your breath. Dip your knees, chest and chin or forehead to the floor, lifting your hips and abdomen up. If this is difficult initially, then lower your knees first, followed by the chest and then the chin before moving your hips up.

Position 7

Inhale. Slide your body forward till your hips are on the floor. Arch your back and chest upwards and drop your head back. Your legs, hips and hands remain on the floor.

Position 8

Exhale. Tuck your toes and without moving your hands and feet, lift your hips as high up as possible (*position 5*) and lower your head between your arms, so that your body forms a triangle.

Position 9

Inhale. Bring your right foot forward between your hands (*position 4*) so that your fingers and toes are lined up together. Move your left leg back with knees touching the floor. Stretch your head upwards.

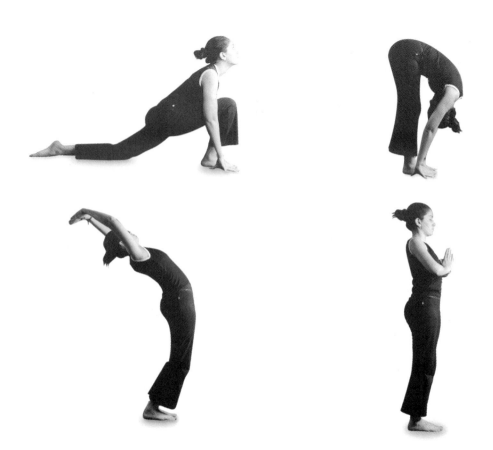

Position 10

Exhale Without moving your hands, bring your left leg forward next to the right foot, hands close to your feet and forehead on your knees (*position 3*).

Position 11

Inhale. Stretch your body up and arch backwards (*position 2*).

Position 12

Exhale. Bring both the palms together in a *namakar* at chest level (*position 1*). Relax.

These 12 positions are practised twice to complete one round of surya namaskar *with the right and left legs alternating by coming forward and moving backward.*

Bandha

These are the locks and the seals that have a powerful effect on the reproductive organs of women. They also help in altering moods, attitude and in enhancing awareness and concentration. *Bandhas* may be practised separately or together with *pranayama*.

Moola Bandha or *Pelvic Floor Exercise*

Exercising the pelvic, anal and vaginal muscles keeps them strong and flexible. As these muscles have been fully stretched for the birth of your baby, they now have to be toned back into their normal state.

- Sit in a comfortable cross-legged position. Close your eyes and relax your body.
- Focus on your anal sphincter, perineal muscles and the vaginal area.
- Inhale. Contract these muscles. Exhale and release these muscles.

Repeat several times.

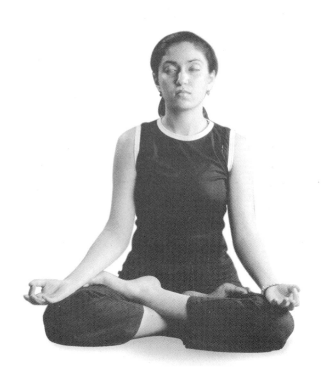

JALANDHARA BANDHA OR CHIN LOCK

This practice regulates your respiratory and circulatory systems, relieves stress and anxiety, producing a state of mental relaxation. The pressing of your chin to your throat helps to balance your thyroid functions and regulate metabolism.

- Sit in a comfortable cross-legged position with the spine erect and the palms placed on your knees. Close your eyes and relax your body.
- Inhale slowly and deeply. Retain your breath and as you do so, drop your head forward and press your chin tightly against your chest.
- Stay in this position for as long as you can hold your breath without any strain.
- Release the chin lock, raise your head and exhale.

Repeat 3 to 4 times.

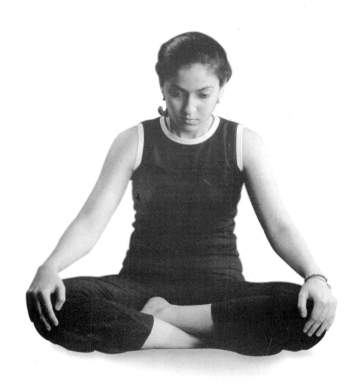

UDDIYANA BANDHA OR ABDOMINAL LOCK

The practice of *uddiyana bandha* stimulates the digestive processes as all the abdominal organs are massaged and toned. It improves blood circulation and strengthens the internal organs. It is a boon for women suffering from ailments like constipation and indigestion.

- Sit in a comfortable cross-legged position with the spine erect and knees touching the floor. Use a cushion under your hips to lift them and drop your knees to the ground.

- Place your palms on your knees, close your eyes and relax your body by breathing deeply.

- Begin by exhaling all the air from your lungs, drawing your navel and abdomen inward into your thoracic cavity, towards your spine.

- Retain your breath for as long as possible without straining.

- To release the stomach lock, inhale slowly and deeply and then resume normal breathing.

Repeat 2 to 3 times.

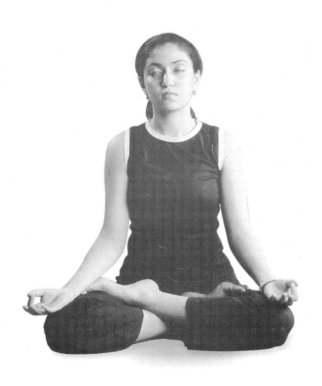

8

Pranayama

Breathing is the most important process in the body as it governs the activities of each and every living cell. It is very closely related to the healthy functioning of all your internal organs, especially your central nervous system and brain. *Yogic* breathing exercises are called *pranayama*. There are two main functions of breathing. The first is to oxygenate the blood and the second is to control your *prana* or vital energy, leading to control of your mind. Most people do not know the correct way of breathing, and this results in using only a small part of their lung capacity. This type of 'shallow breathing' actually deprives your body of the right quantity of oxygen required for your body's health.

Therefore, through *yogic* breathing or *pranayama*, we learn the correct techniques of breathing, which will lead to increased vitality and strength. *Pranayama* also steadies your emotions and creates greater clarity of mind.

Everyone who practises *yogic* breathing benefits greatly. Those Moms with post-pregnancy anxieties, post partum depression, lack of sleep and lethargy will soon feel much more positive and relaxed

after starting these easy exercises. A feeling of calmness and control will set in as you progress, and you will find it easier to cope with your new responsibilities.

Before we embark on our learning of *pranayama*, it is important to follow a few guidelines:

1. The best position for *pranayama* is sitting on the floor cross-legged, with spine, neck and head held in a straight line.

2. During practice, your facial muscles, eyes, shoulders and arms should not be tense, but relaxed.

3. All breathing should be done through your nostrils and not through the mouth, unless specified.

4. Always try to keep your eyes closed so that your mind does not get distracted.

5. Your fingers should be in the *chin mudra*, i.e. your forefinger should be bent towards your thumb, with your finger tip touching the tip of the thumb.

6. *Pranayama* is normally practised after the *asanas* but you can perform it before the *asanas*. The important thing is to treat it as an important part of your yoga session.

7. Like the *asanas*, *pranayama* has to be done on an empty stomach.

8. After the practice of *pranayama*, lie down in *shavasana* for a few minutes.

Never try and increase your capacity too fast. Practise *pranayama* for a specific length of time before moving on to more advanced exercises.

'When the breath wanders, the mind is unsteady. But when the breath is still, so is the mind and the yogi lives long. So one should restrain the breath.'

—Hatha Yoga Pradipika

YOGIC BREATHING

This technique helps you to focus on your breathing movements and relaxes you completely.

- Sit in a cross-legged position, or lie down in *shavasana*. Relax your whole body.
- Inhale slowly. Feel your abdomen expand, then your rib cage followed by your upper chest. This is one complete inhalation.
- Now exhale. The air will leave your lower neck and upper chest, moving your chest downward.
- Empty your lungs completely by drawing your abdominal wall as close to your spine as possible.

Try to do five to 10 rounds of this breathing exercise, and increase gradually to 20 rounds.

Your breathing should be in one continuous movement.

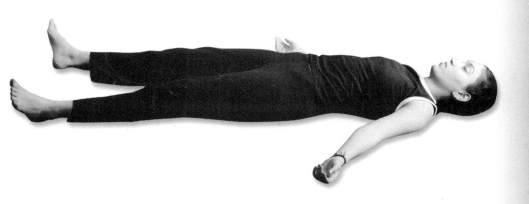

KAPALABHATI PRANAYAMA

In Sanskrit, *kapala* means 'skull' and *bhati* means 'shining'. It means that if you practise this *pranayama*, your face will glow with good health. This *pranayama* purifies your entire system and releases toxins from your body. Your mind is energised and prepared for meditation. It strengthens your nervous system and tones your digestive organs.

- Sit in a comfortable cross-legged position, keeping your spine straight and hands resting on your knees in the *chin mudra*. Relax your body and breathe deeply.

- Inhale deeply through the nostrils, expanding your abdomen.

- Exhale with a forceful contraction of your abdominal muscles, expelling the air out of your lungs.

- Inhale again, but passively allow your abdominal muscles to expand and inflate your lungs with air without any force. This is a pumping effect in passive inhalation and expulsion of breath in a continuous manner.

- Do 15 to 20 breath expulsions. Then inhale and exhale deeply for 1 to 2 rounds, followed by retaining of breath for 20 to 30 seconds.

Practise three rounds of *kapalabhati*.
Take care not to strain. Your facial muscles should be relaxed. If you feel any pain or dizziness, stop for some time. Those who suffer from high blood pressure, vertigo, any ear or eye complaints should avoid this.

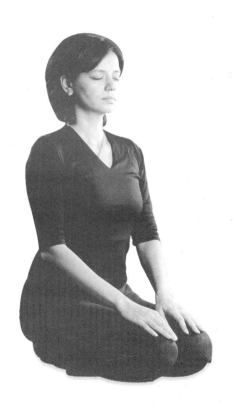

Ujjayi Pranayama

This *pranayama* is excellent for increasing your endurance levels, soothing your nerves and toning your entire nervous system.

- Sit in a comfortable cross-legged position with eyes closed. Relax your body. Allow your breath to become calm and rhythmic.
- Inhale deeply from both nostrils through the throat, partially keeping your glottis closed in order to produce a sound of low uniform pitch (*sa*).
- Fill your lungs, but take care not to bloat your stomach.
- Exhale slowly and deeply until your lungs are empty. As you exhale, the air should be felt on the roof of the palate while making a sound (*ha*). These sounds should be so silent that only you should able to hear them.

Repeat 10 to 15 times, twice a day.

This completes the first sequence of this pranayama. *Wait for a few seconds to begin the next round.*

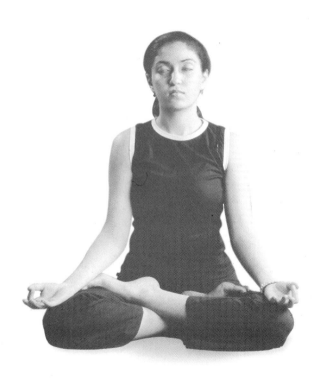

Nadi Shodhana or Alternate Nostril Breathing

In this *pranayama*, your blood receives a larger supply of oxygen than in normal breathing; your mind feels very relaxed and calm. It not only soothes your entire nervous system but also increases vitality, clarity and lowers stress levels.

- Sit in a comfortable cross-legged position. Relax your entire body and keep your eyes closed. Allow your breath to become calm and rhythmic.

- Bend your right arm from the elbow. Fold your middle and index fingers inward to your palms. Bring your ring finger and the little finger towards your thumb.

- Place your right thumb on the right side of your nose and your ring and little fingers on the left side of your nose. By pressing your thumb, you block your right nostril.

- Inhale slowly and deeply through your left nostril to the count of 4. After a full inhalation, block your left nostril with your ring and little fingers and retain your breath to the count of 16. Simultaneously apply the *jalandhara, moola* and *uddiyana bandha* (if you can).

- Exhale, releasing the pressure from your right nostril and breathing out the air slowly, deeply and steadily to the count of 8. Release the *bandhas* at the same time.

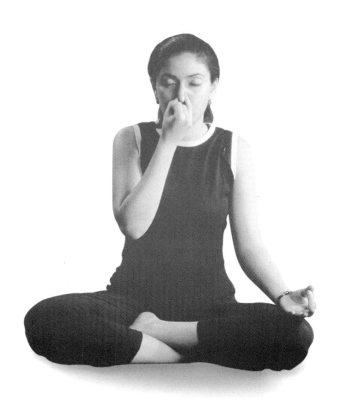

- Next, blocking your left nostril, inhale deeply from the right nostril to the count of 4. After a full inhalation, retain your breath for 16 counts. Applying the *bandhas*, block your right nostril. Exhale slowly, deeply and steadily for 8 counts, simultaneously releasing the pressure from the left nostril slowly.

This completes one round of the *pranayama*. Try to do 5 to 8 rounds and gradually increase from 10 to 12 rounds.

Lie down in *shavasana* and relax.

Do not force your breath and never breathe through your mouth. At any slight discomfort reduce the duration of inhalation, retention and exhalation. Practise this pranayama *with full awareness and during breath retention, focus your eyes to the point between the eyebrows* (ajna chakra).

9

Relaxation

Yoga relaxation techniques help to calm your mind and you will experience a sense of inner peace and tranquility. As you learn to handle all the stresses of early motherhood, daily relaxation exercises will take away all your tension and fatigue and keep your body and mind rejuvenated.

Post-pregnancy, as your body's progesterone and estrogen levels start returning to normal, you will also experience mood swings and lethargy caused by hormonal imbalances. This is absolutely normal and relaxation exercises will help you to cope wonderfully with emotional ups and downs, as you go through these natural stages.

The best method to get your body and mind to relax is through the use of autosuggestion. You will programme your conscious and subconscious to relax. Just follow this simple routine and reap the immense physical and emotional benefits.

'Meditation is the key to becoming a more spiritual person... the thoughts calm down and ego consciousness is able to metamorphose into soul consciousness.'

—*Swami Ishtananda Giri*

103

Yoga Nidra (Relaxation)

- Lie in the *shavasana* position. Relax your body and breathe.
- Inhale. Tense all your body muscles (including facial muscles) and release with an exhalation.
- Now let your mind travel through the body and focus on relaxing mentally each body part systematically, till your entire body is relaxed.
- Let yourself go and sink into the quietness of the mind.
- To bring your consciousness back to your body, gently move your fingers and toes, take a deep breath and as you inhale, sit up.

Take care not to sleep while doing this exercise.

Yoga Nidra

This is an important exercise for new Moms who need to catch up on their sleep!

- Lie down in *shavasana*. Keep your eyes closed and relax your body.
- Tense all your body muscles, including the facial muscles. Inhale and release with an exhalation.
- Move your head from side to side and relax your entire body.
- Shift your awareness to your breathing, inhaling and exhaling slowly and steadily.

Count 10 breaths lying on your back, 20 breaths lying on your right side and 40 lying on your left side.

Take care not to miss a count. If you do, then begin the count from the beginning.

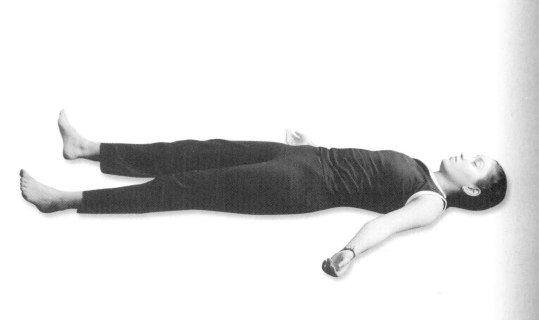

10

Meditation

Meditation is the process of making the mind still against outside distractions to discover peace and wisdom within your self. Regular meditation will give you a greater sense of who you are and what you want. It helps you to centre your mind and calmly face external influences.

As a new Mom, you have a lot of responsibility. Besides taking care of your baby, you also are still taking care of your home and career. And juggling all these responsibilities, which often clash, leads to a lot of stress and anxiety. Many first-time Moms are understandably unsure of themselves and of their ability to take care of a tiny infant. And though your self-confidence will grow quickly, the first months are often particularly difficult, especially if there is no help or support on hand. Nearly all mothers feel somewhat depressed after their baby is born, due to the hormonal changes, and this makes them feel emotionally drained. To keep your balance throughout this period, it becomes very important to take time out to practise the simple techniques of meditation.

To begin the practice of meditation, it is best to follow a few rules

like practice at a regular time and at the same place. Try to face north or east. Sit in a comfortable cross-legged position or any meditative posture. If keeping your spine straight for a long time is uncomfortable, then lean against the wall and continue the practise. To begin with, sit still for a few minutes, and as you progress through your practice, try to still the mind from all thoughts. The true signs of progress in meditation are:

- The feeling of total silence of your mind and the stillness of your body.
- An immense feeling of peacefulness within.
- Increase in your mental and physical efficiency in daily life.
- A feeling of total bliss and calmness.
- Love for meditation and the desire to continue the practice.

'Count on making progress and not on measuring it.'
—Sri Sri Pramahansa Yogananda

Soham Meditation

This meditation has a calming effect. As all thoughts are released from your mind, you will feel a state of immense serenity and stillness.

- Sit in a meditative posture. Relax your body and mind.
- Focus on the part of your breath that touches the sides of your nostrils. Let thoughts come and go without distracting you.
- As you inhale, hear the sound *'so'* in your mind as you inhale. And as you exhale, hear the sound *'hum'*. Let your breath flow at its natural pace, but focus on hearing these two sounds in your mind.
- Continue to do this for at least 20 minutes and then lie down in *shavasana*.

MANTRA MEDITATION

In this meditation, the word or *mantra* focuses your mind and body to release the stress and you achieve mental clarity and health.

- Sit in a meditative posture. Relax your body and mind.

- Pick a word, any word that feels good when you say it, like peace or serenity, or a *mantra* like *gayatri mantra*.

- Repeat the word or *mantra,* chant the word, focus on nothing but say the word over and over again. Let the sound of the word or *mantra* vibrate through your body for 20 minutes and then lie down in *shavasana*.

11

Eating Right for You and Your Baby

To get the most out of yoga, it is very important that you eat right. Food is your body's main source of energy and it has a lot of healing and curative value. It has been rightly proved by *yogis* that our body and mind are made up of the food we eat. The first important rule of weight loss is to make healthy food choices.

In *yogic* terms, you need to eat *satvic* food—pure and natural food that will increase your vigour and vitality and bring energy to your body. You should avoid *rajasic* food (hot, bitter and dry) and *tamasic* food that is tasteless, impure, stale or rotten.

Switch to natural and fresh foods for your nutritive requirements. These are available in abundance. Make sure that the food is eaten as far as possible in its natural state or cooked very lightly, as prolonged contact with heat destroys the food's nutritive value.

Eat two to three servings of fruit daily. Drink lots of fruit juices as they supply the body with life-giving vitamins, minerals and fibre. Vegetables are as important as fruits and they should preferably be

cooked very lightly or eaten raw in the form of salads.

Make sure your diet contains enough of proteins. Food rich in protein are nuts, pulses, seeds, egg, lentils, milk and cottage cheese.

Carbohydrates are our chief source of energy. Foods rich in starch are whole grains, wheat germs, rice and sugar.

Water is vital. It makes up two-thirds of our body weight and helps in flushing the toxins out of our body. Drink at least 10 to 12 glasses of water a day. Avoid drinking water half an hour before or after meals. This just dilutes your gastric juices and hinders digestion.

Whilst lactating, you need plenty of calcium and iron. And as when you are pregnant, it is a good idea to avoid caffeine and alcohol as they can enter your breast milk and harm your baby physically, or cause her to be irritable.

A newborn baby is dependent on its mother for sustenance, and will continue to be so at least for the first three to six months. You must breastfeed your baby as mother's milk has all the right amount of nutrients and minerals that your baby needs, and it is sterile. Breast-fed babies contract fewer infections and are healthier. So it is very important that you eat a good balanced diet for both your baby and yourself, yet lose that extra weight.

Here are some practical guidelines that will help you to regulate your eating habits:

1. Never ever overeat. This is the worst thing you can do for your body. Eat the right amount of food according to your body's requirements and the physical activity you perform.

Always remember to keep your stomach a little empty for your body to perform its natural function of digestion well.

2. Eat three meals a day, or space your eating into four to five meals, based on your body's needs. But make sure the quantity always remains the same.

3. Never miss breakfast, as it is the most important meal of the day after a fast of 10 to 12 hours. Breakfast gives you energy for the entire day.

4. Make a deadline for the last meal of the day and make sure that you do not eat anything past this deadline.

5. Replace the use of refined sugar with a healthier, natural sweetener—honey. Avoid food rich in spices as this leads to acidity and heartburn.

6. Eat only freshly cooked food and not stale or old food that is kept in the fridge. Avoid deep-fried food as it is indigestible and the nutrients are destroyed while frying.

7. Fast at least once a week (not when you are breast feeding) and live on fruit juice for the day. This provides time to your body to flush out toxins from the body.

8. Try to cut down on the three whites from your diet—flour, sugar and salt.

9. Avoid excess fat.

10. Make a journal and write your daily diet and exercise routine.

Also note any deviations. Documentation will help you to stay focused, track lapses and help you understand yourself better.

11. Talk to friends about your weight-loss plan, learn from their experiences and share yours with them. The exchange of information helps you to benchmark yourself as you progress and will renew the commitment that you have made with yourself.

There is no doubt that with a proper diet and yogic discipline, you will lose the extra weight but remember to be motivated and committed to your purpose. Reward yourself for achievements and punish yourself for lapses.

'Your food is not just food: it is you. What you eat, you become.

—Osho

Yoga: Not a Change in Lifestyle

Before embarking upon the practice of yoga, it is important for you to know that yoga will in no way change, hamper or inhibit your lifestyle. You are absolutely free to carry on with any kind of lifestyle you choose for yourself and your family. Whether your get up early in the morning or late, whether you eat lunch at 12 noon or 1.00 p.m. or 2.30 p.m., whether you picnic every Sunday or dance every Saturday, or you are a vegetarian or non-vegetarian, it just does not matter. You can practise yoga comfortably no matter what your living habits are. All it needs is a little time, a small space and a commitment.

Many people are attracted to yoga as a way to keep supple and fit. Others use it as a therapeutic instrument for the body or mind. Either way, it is not a lifestyle sport or hobby. Instead, it is a means of fulfillment. Yoga will help you towards leading a much more fulfilled life physically, mentally and socially.

Though in this book we have focused on post-pregnancy exercises, you can practice yoga at any age and stage in life, from early

childhood, through youth and maturity and all the way through to your later years.

Yoga will help you towards leading a much more fulfilled life physically, mentally and socially. Though in this book we have focused on post-pregnancy exercises, yoga can be practised at any age and stage in life.

We hope you found this book useful in your aim to get your body back into shape after you've had your baby.

'The senses are more powerful than the objects of desire. Greater than the senses is the mind, higher than the mind is reason, and superior to reason is He, the spirit of all. Discipline yourself by the self and destroy your deceptive enemy in the shape of desire.'
—**Bhagwad Gita**